THE
Baker's Dozen
COLORING BOOK

PICTURES BY WENDY EDELSON • STORY BY AARON SHEPARD

A SKYHOOK COLORING STORYBOOK

What is a "coloring storybook"? It's a coloring book, a storybook, and more! You can color just the pages you want, and enjoy it like any fine coloring book. Or finish them all and create a wonderful storybook, a keepsake all your own, or one to lovingly share with children and grandchildren. Imagine their excitement—and yours too!—when you read to them from a book you helped illustrate yourself! It's a gift your loved ones can treasure forever, a true family heirloom.

This coloring storybook from Skyhook Press, based on an authentic legend, reveals the origin of the term "baker's dozen" and tells how Saint Nicholas taught a baker to be generous.

Please note: This "grayscale coloring book" has pictures already shaded in gray, calling for a different kind of coloring. But that doesn't make it harder—in fact, it makes it easier to get stunning results! For tips, search online for "grayscale coloring."

Version 1.1

Why Choose This Coloring Storybook?

• Adapted from a beloved children's picture book, with an inspiring traditional Christmas legend retold by award-winning children's author Aaron Shepard, and 15 pages of lovely, finely detailed art by award-winning children's illustrator Wendy Edelson.

• For stunning results, pictures are all in grayscale, but grayscale with a difference! Much of the gray has been removed to reduce the risk of muddiness and allow more natural flesh tones, while deepest blacks have been preserved to provide full contrast.

• Pictures are printed on one side of the paper only and framed with black for cleaner edges and dramatic presentation.

• High-quality seventy-pound paper, pure white for maximum brightness, contrast, and color fidelity. With smooth, matte coating to reduce bleed and feathering and to consume less of your coloring media. Acid-free to last for generations without becoming yellow or brittle.

• Printed on a color press with a high-density line screen for superior detail and tonal depth, but using black ink alone on all coloring pictures to avoid tinting.

• Blank lines right on the title page for colorist's signature and date.

• Bonus picture page at the end for tests, experiments, or practice.

• Thumbnails of original color illustrations on the back cover to serve as suggestions, examples, and inspiration.

• Available in both paperback and hardcover, with no difference in paper. Choose between economy and ultimate durability—or practice on the paperback before tackling the hardcover!

• Pages may be freely copied for personal use. Practice on as many copies as you like before coloring in the book!

• Colored pages may be freely shared. Show off your work, give as gifts, or even sell as pieces of original art.

THE BAKER'S DOZEN
A Saint Nicholas Tale

Told by Aaron Shepard • Pictures by Wendy Edelson
Coloring by

_____ _____
NAME DATE

Skyhook Press
Bellingham, Washington

In the Dutch colonial town later known as Albany, New York,

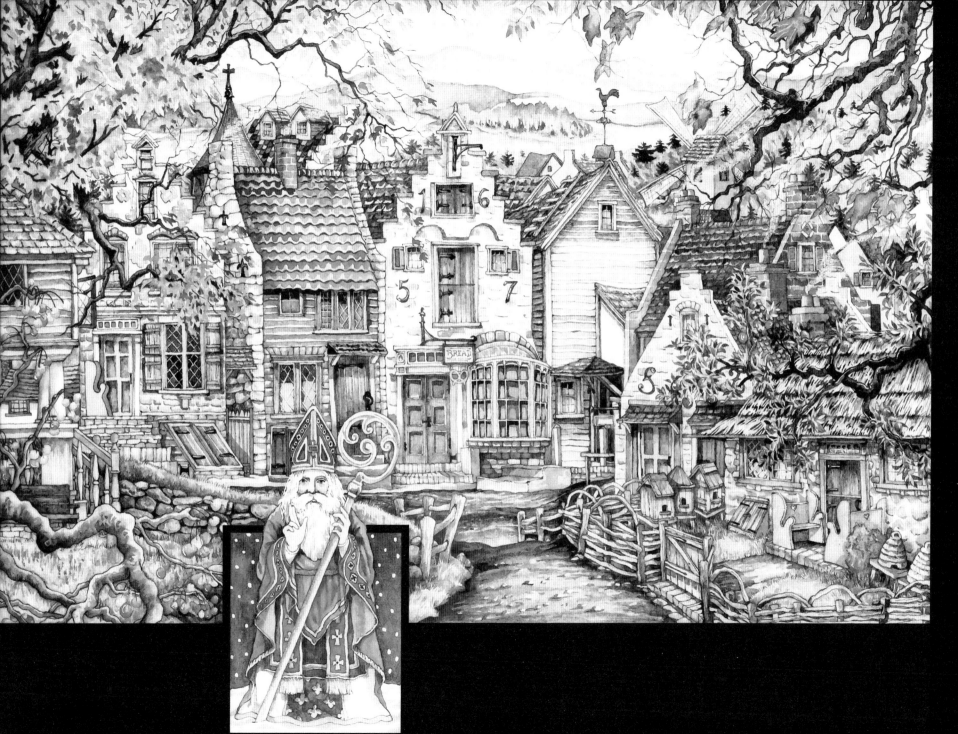

there lived a baker, Van Amsterdam, who was as honest as he could be. Each morning, he checked and balanced his scales, and he took great care to give his customers exactly what they paid for—not more and not less.

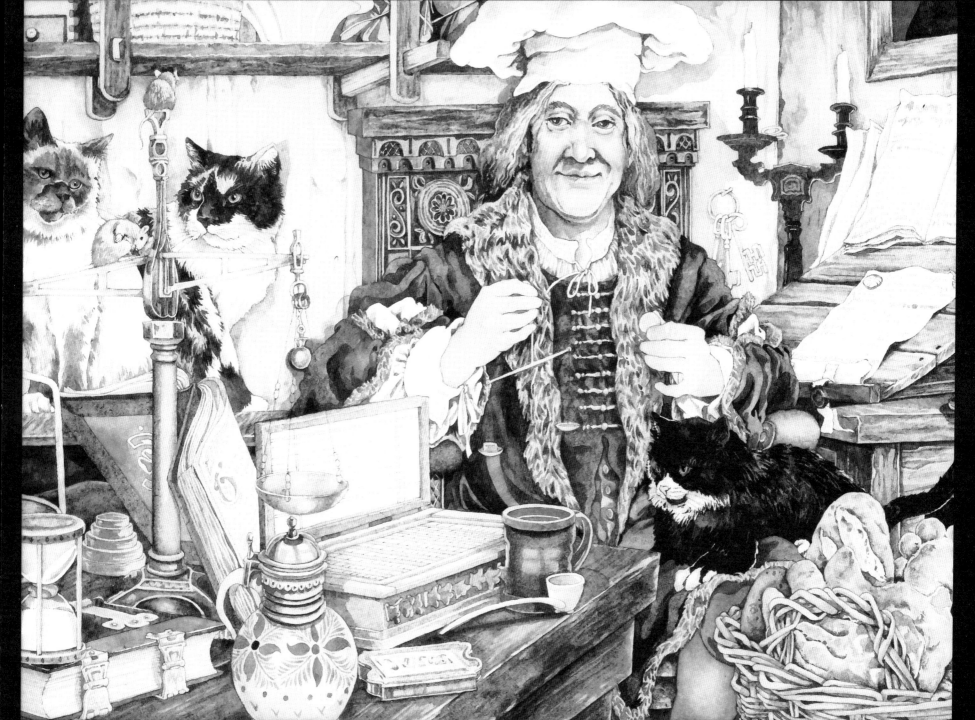

Van Amsterdam's shop was always busy, because people trusted him, and because he was a good baker as well. And never was the shop busier than in the days before December 6, when the Dutch celebrate Saint Nicholas Day.

At that time of year, people flocked to the baker's shop to buy his fine Saint Nicholas cookies. Made of gingerbread, iced in red and white, they looked just like Saint Nicholas as the Dutch know him—tall and thin, with a high, red bishop's cap, and a long, red bishop's cloak.

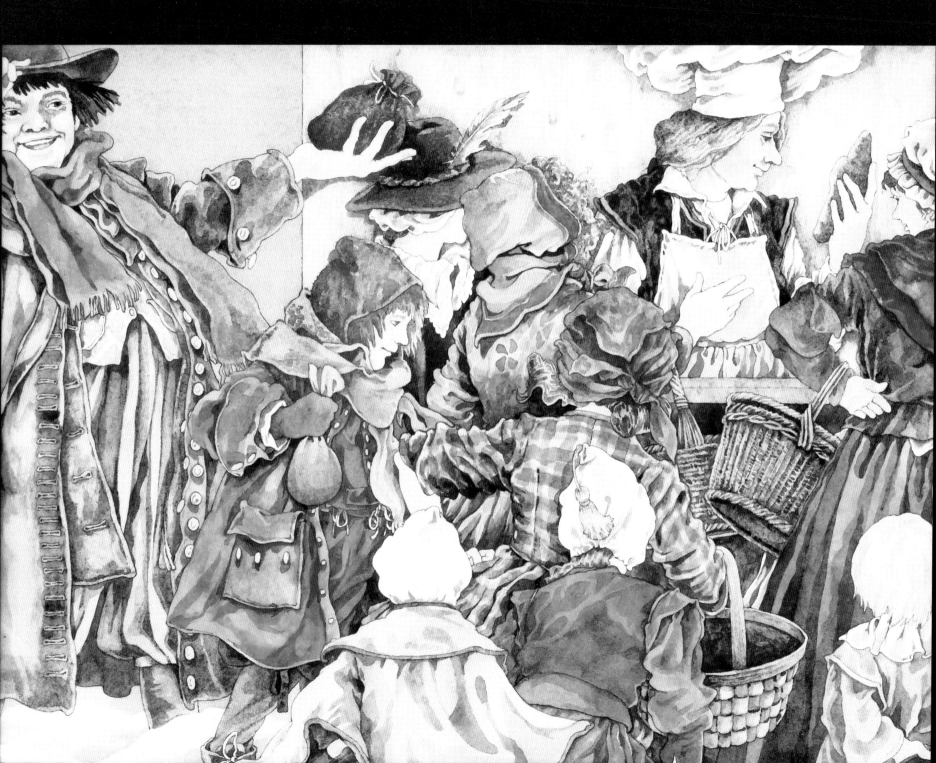

One Saint Nicholas Day morning, the baker was just ready for business, when the door of his shop flew open. In walked an old woman, wrapped in a long black shawl.

"I have come for a dozen of your Saint Nicholas cookies."

Taking a tray, Van Amsterdam counted out twelve cookies. He started to wrap them, but the woman reached out and stopped him.

"I asked for a dozen. You have given me only twelve."

"Madam," said the baker, "everyone knows that a dozen *is* twelve."

"But I say a dozen is thirteen," said the woman. "Give me one more."

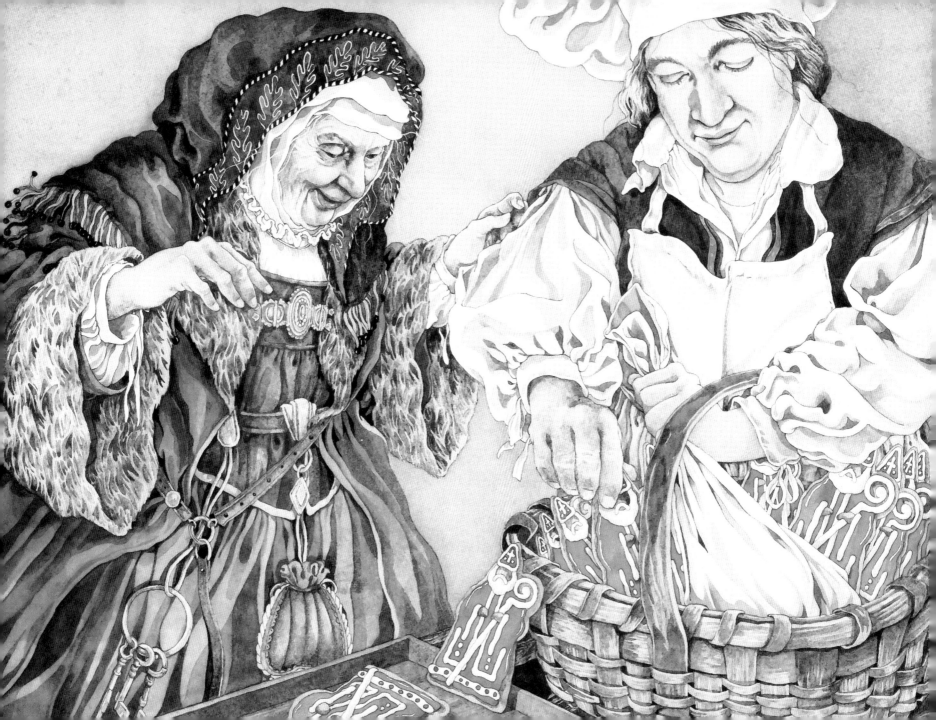

Van Amsterdam was not a man to bear foolishness. "Madam, my customers get exactly what they pay for— not more and not less."

"Then you may keep the cookies."

The woman turned to go, but stopped at the door.

"Van Amsterdam! However honest you may be, your heart is small and your fist is tight. *Fall again, mount again, learn how to count again!*"

Then she was gone.

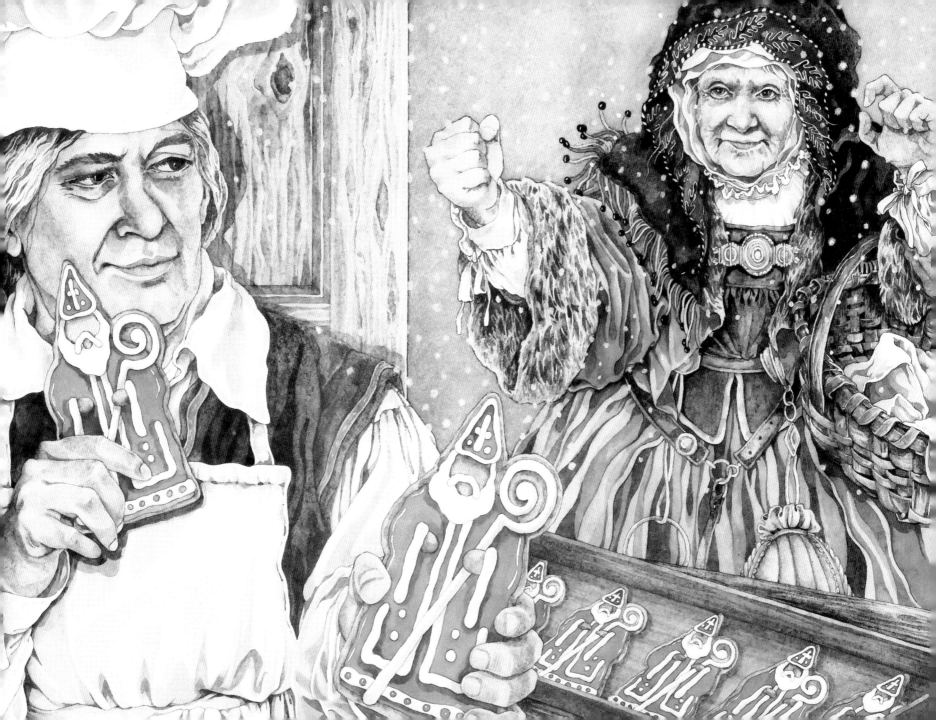

From that day, everything went wrong in Van Amsterdam's bakery. His bread rose too high or not at all. His pies were sour or too sweet. His cakes crumbled or were chewy. His cookies were burnt or doughy.

His customers soon noticed the difference. Before long, most of them were going to other bakers.

"That old woman has bewitched me," said the baker to himself. "Is this how my honesty is rewarded?"

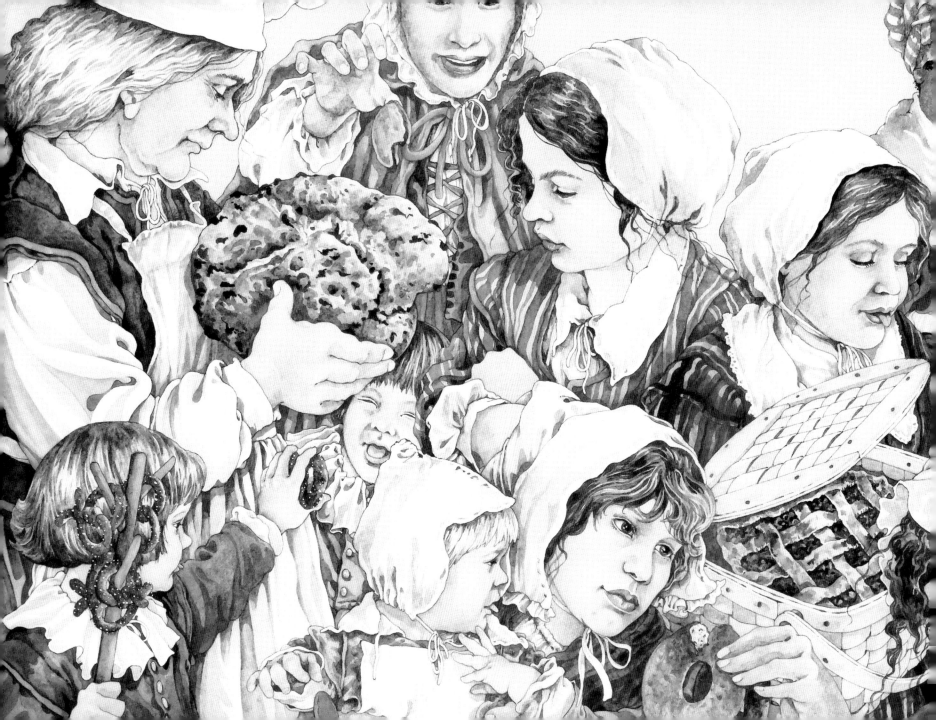

A year passed. The baker grew poorer and poorer. Since he sold little, he baked little, and his shelves were nearly bare. His last few customers slipped away.

Finally, on the day before Saint Nicholas Day, not one customer came to Van Amsterdam's shop. At day's end, the baker sat alone, staring at his unsold Saint Nicholas cookies.

"I wish Saint Nicholas could help me now," he said. Then he closed his shop and went sadly to bed.

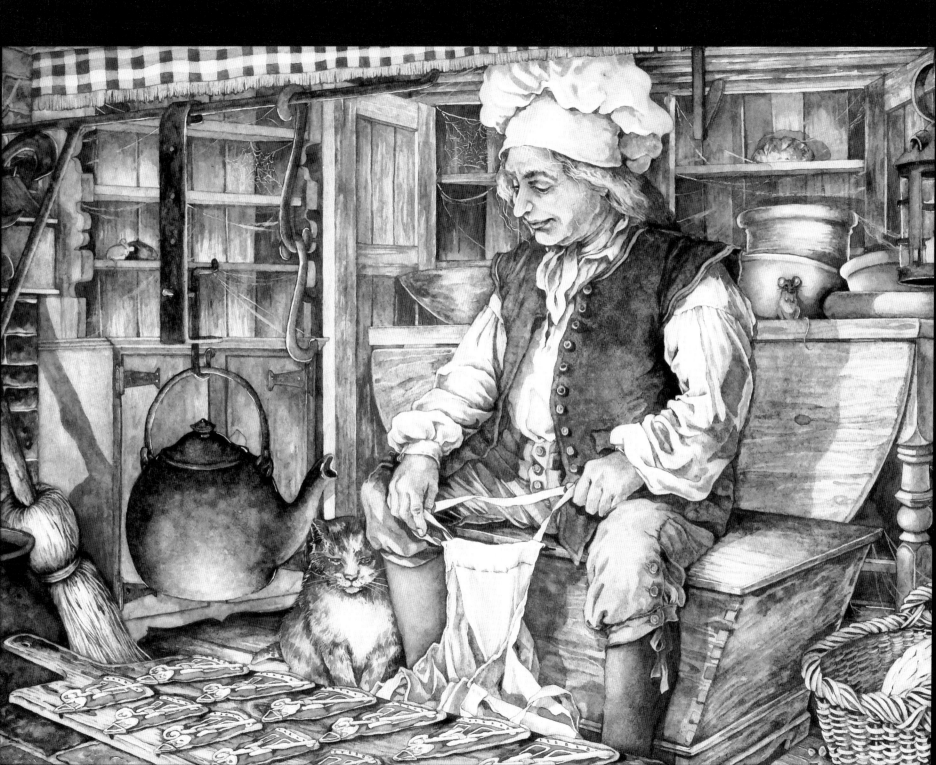

That night, the baker had a dream. He was a boy again, one in a crowd of happy children. And there in the midst of them was Saint Nicholas himself.

The bishop's white horse stood beside him, its baskets filled with gifts. Nicholas pulled out one gift after another, and handed them to the children. But Van Amsterdam noticed something strange. No matter how many presents Nicholas passed out, there were always more to give. In fact, the more he took from the baskets, the more they seemed to hold.

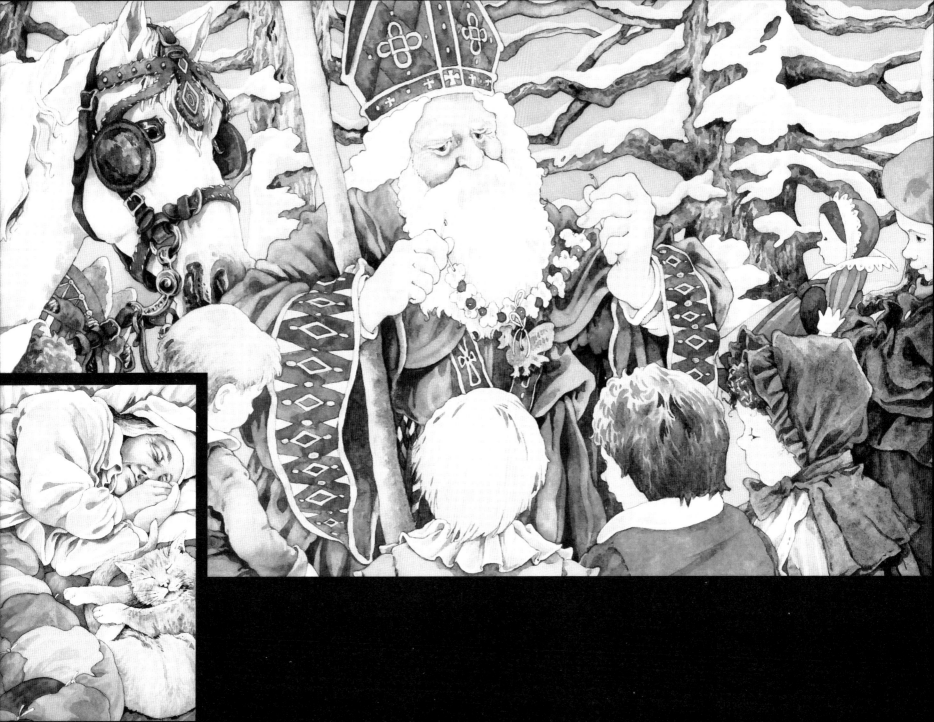

Then Nicholas handed a gift to Van Amsterdam. It was one of the baker's own Saint Nicholas cookies! Van Amsterdam looked up to thank him, but it was no longer Saint Nicholas standing there.

Smiling down at him was the old woman with the long black shawl.

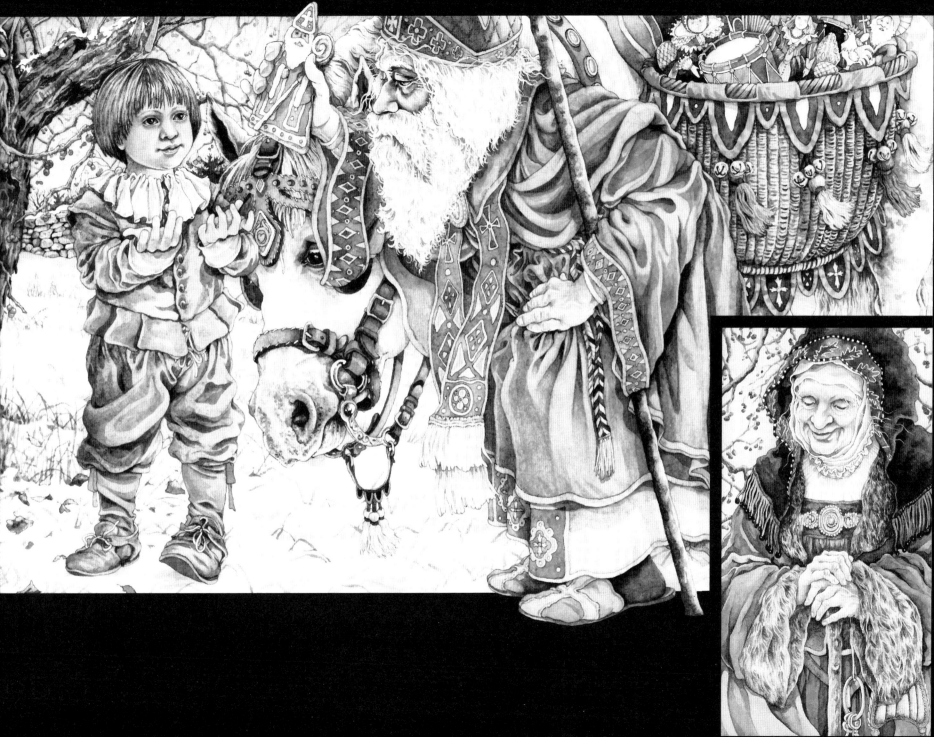

Van Amsterdam awoke with a start. Moonlight shone through the half-closed shutters as he lay there, thinking.

"I always give my customers exactly what they pay for," he said, "not more and not less. But why *not* give more?"

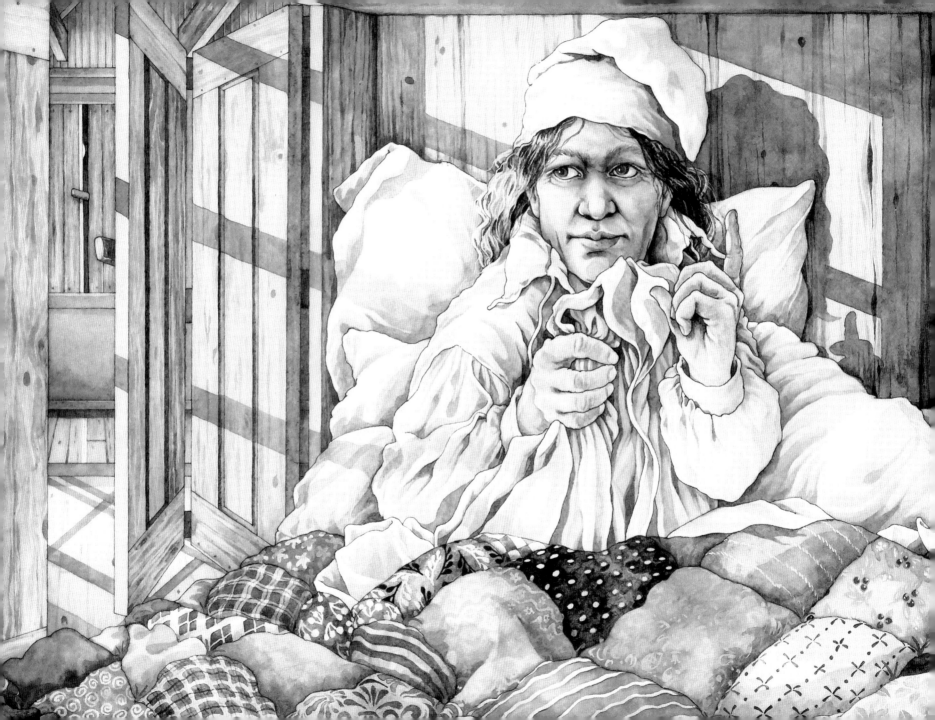

The next morning, Saint Nicholas Day, the baker rose early. He mixed his gingerbread dough and rolled it out. He molded the shapes and baked them. He iced them in red and white to look just like Saint Nicholas. And the cookies were as fine as any he had made.

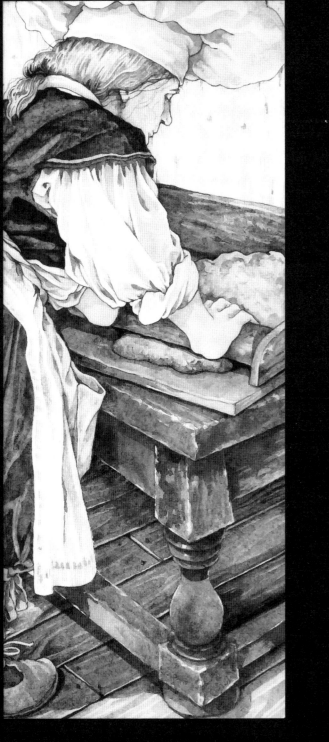
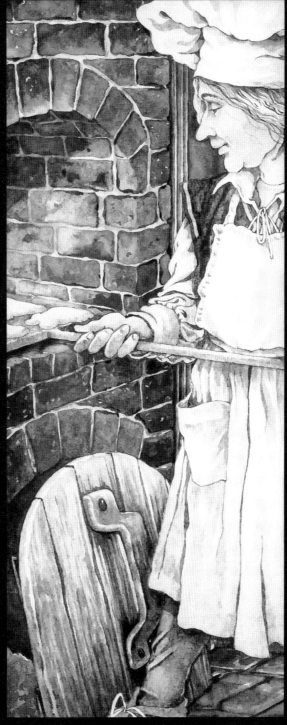
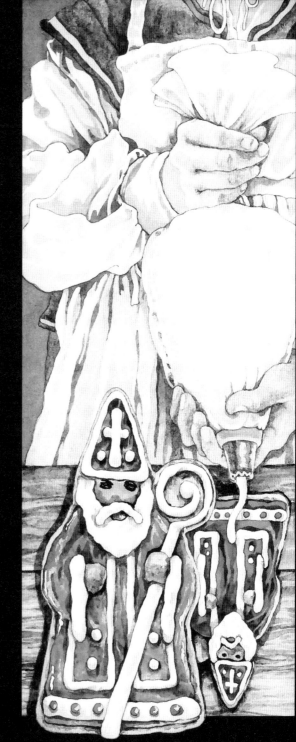

Van Amsterdam had just finished, when the door flew open. In walked the old woman with the long black shawl.

"I have come for a dozen of your Saint Nicholas cookies."

In great excitement, Van Amsterdam counted out twelve cookies—and one more.

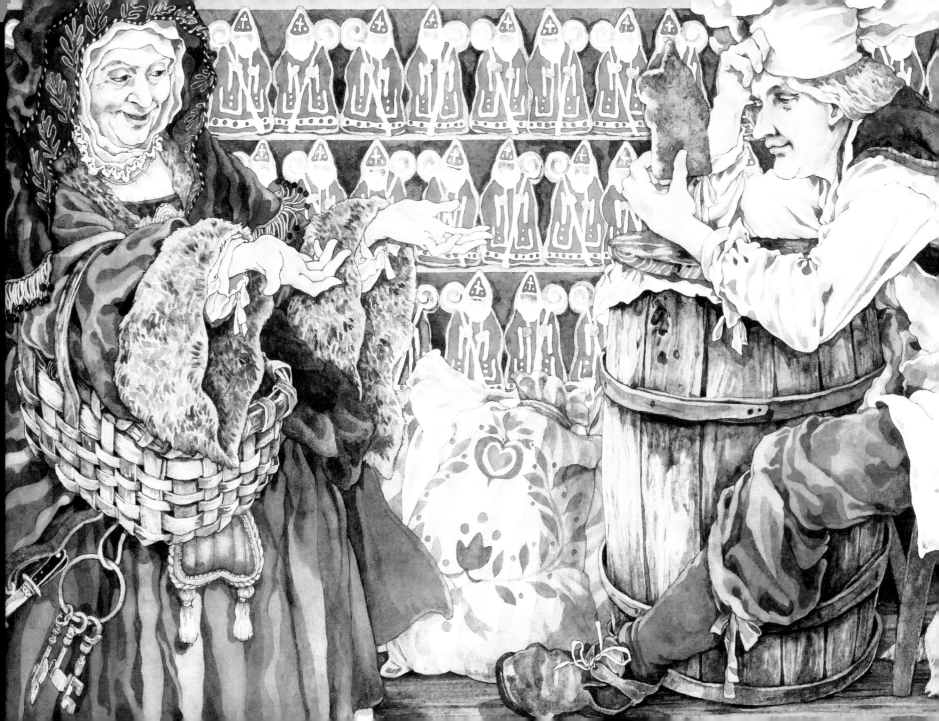

"In this shop," he said, "from now on, a dozen is thirteen."

"You have learned to count well," said the woman. "You will surely be rewarded."

She paid for the cookies and started out. But as the door swung shut, the baker's eyes seemed to play a trick on him. He thought he glimpsed the tail end of a long red cloak.

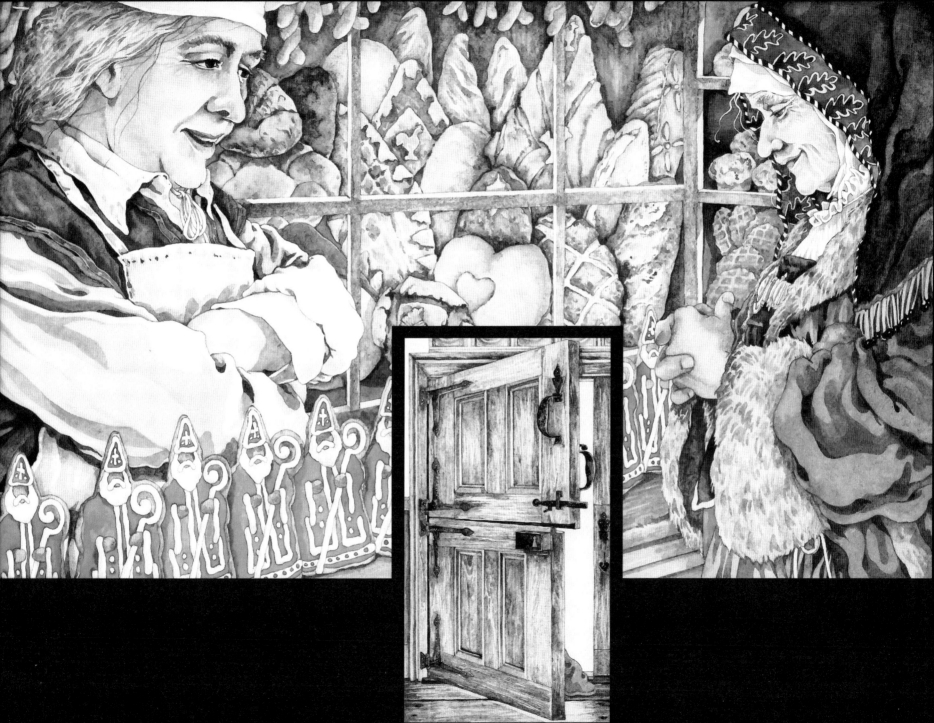

As the old woman foretold, Van Amsterdam *was* rewarded. When people heard he counted thirteen as a dozen, he had more customers than ever.

In fact, Van Amsterdam grew so wealthy that the other bakers in town began doing the same. From there, the practice spread to other towns, and at last through all the American colonies.

And this, they say, is how thirteen became the "baker's dozen"—a custom common for over a century,

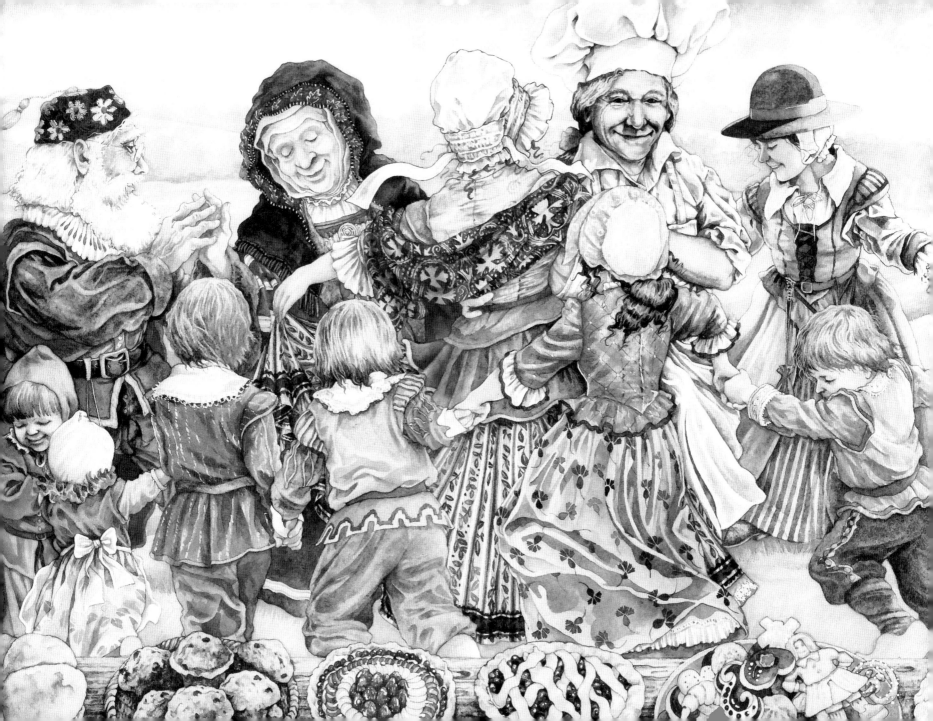

and alive in some places to this day.

About the Children's Book

This coloring book is adapted from the children's picture book *The Baker's Dozen: A Saint Nicholas Tale*, told by Aaron Shepard and illustrated by Wendy Edelson. The book was published in 1995 by Atheneum Books for Young Children, an imprint of Simon & Schuster, and was honored as an *American Bookseller* Pick of the Lists and a Trumpet Book Club Selection. It is still available, in a new edition from Skyhook Press with bonus cookie recipe and pattern.

About the Artist

Wendy Edelson has applied her award-winning skills to a wide range of illustration projects, including picture books, pet portraits, posters, and puzzles. Among her clients have been Seattle's Woodland Park Zoo, the Seattle Aquarium, Pacific Northwest Ballet, the U.S. Postal Service, *Cricket Magazine*, McGraw-Hill Education, and the American Library Association. Her more recent projects have included several picture books and coloring books for Skyhook Press. The pictures in this coloring book were converted to grayscale from Wendy's original watercolor illustrations. Visit her at **www.wendyedelson.com**.

About the Author

Aaron Shepard is the award-winning author of many children's books from publishers large and small. Once a professional storyteller, Aaron specializes in lively retellings of folktales and other traditional literature, which have won him honors from the American Library Association, the New York Public Library, the Bank Street College of Education, the National Council for the Social Studies, and the American Folklore Society. After first hearing the legend of the baker's dozen from storyteller Sheila Dailey, Aaron retold the story himself with the help of texts dating as far back as 1896. Visit him at **www.aaronshep.com**.

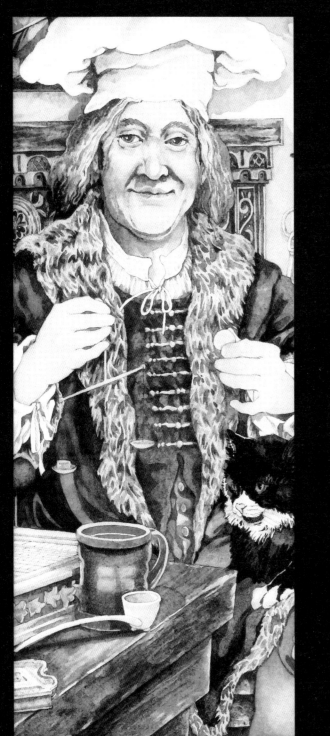
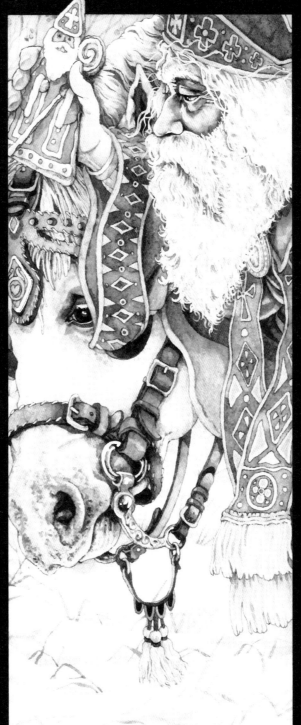
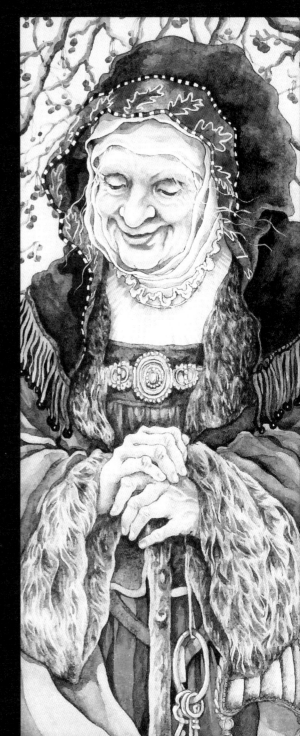

More Grayscale Coloring . . .

THE
QUACKLING
COLORING BOOK
WENDY EDELSON · AARON SHEPARD

THE
SKEETER
AND THE
WEASELS
COLORING BOOK
ANNE L. WATSON AARON SHEPARD

More Grayscale Coloring . . .

CPSIA information can be obtained at www.ICGtesting.com
Printed in the USA
BVIW120926131120
593076BV00013B/188